罗伯特·M. 波西格在维修摩托车。1975年。　供图：WILLIAM MORROW

目录
CONTENTS

关于作者 04
ABOUT THE AUTHOR
走近波西格 05
MEET ROBERT M. PIRSIG
与波西格对话 08
A CONVERSATION WITH ROBERT M. PIRSIG

关于本书 22
ABOUT THE BOOK
波西格关于《莱拉》的介绍 23
INTRODUCTION FROM ROBERT M. PIRSIG
徐英瑾关于《莱拉》的导读：溯流而上的"良质"探究传奇 26
INTERPRETATION FROM XU YINGJIN

拓展阅读 34
READ ON
《莱拉》背后的作家与作品 36
BOOKS AND BEYOND
《莱拉》全球媒体评论 44
PRAISE FOR *LILA*

ABOUT THE AUTHOR

关于作者

MEET ROBERT M. PIRSIG
走近波西格

一九二八年，罗伯特·M.波西格出生于明尼苏达州的明尼阿波利斯。他很早就表现出化学方面的天赋，却因不能从中发现任何真实的终极意义而止步。他陷入抑郁，无法专注于学业，被迫从大学退学。然后他参军去了韩国，在那里的所见所闻使他转向东方哲学。返回美国后，他在明尼苏达大学获得哲学学士学位，又去贝拿勒斯印度大学学习过一段时间东方哲学，之后再次回到明尼阿波利斯学习新闻专业，并成为自由撰稿人。在二十世纪五十年代后期，波西格和他的妻子南茜生了两个儿子——克里斯和泰德，同时他在蒙大拿州立大学短暂地教授过英文，之后去了伊利诺伊州的芝加哥大学学习哲学。

一九六〇年十二月，波西格患上严重的抑郁症，被送往伊利诺伊州精神病院，后又转至明尼阿波利斯的另一家医院。一九六三

年，他在那里接受了电休克疗法。康复后，他于一九六七年开始写作一篇关于摩托车维修的轻松随笔，这就是《禅与摩托车维修艺术》的肇始。一九六八年六月，波西格给一百二十二家出版商写信，宣称自己想就精神与技术生活中彼此割裂的问题写一本书。一个月后，他与克里斯开始了一次摩托车之旅，这场旅行后来成为《禅与摩托车维修艺术》的基本情节。

波西格花费四年时间完成此书，最终由威廉马洛公司(William Morrow & Co.)在一九七四年出版，并立即获得评论与商业的巨大成功。此后，波西格沿着东海岸和加勒比一带航行，度过了七十年代余下的几年。其中，他于一九七五年在哈德逊河的游历成为《莱拉：一场对道德的探究》(Lila: An Inquiry Into Morals)一书的基础，这是他的第二部哲学作品，于一九九一年出版。然而，在该书出版之前，波西格的儿子克里斯于一九七九年在洛杉矶惨遭杀害。波西格则经历了离婚、再婚，并于一九八一年有了一个女儿妮尔。整个二十世纪八十及九十年代，波西格都生活在瑞典和美国新罕布什尔州。二〇一七年四月二十四日，波西格于缅因州南贝里克的家中病逝。

《禅与摩托车维修艺术》
英文第一版，精装，由威廉·马洛公司(William Morrow)于1974年出版。

《莱拉：一场对道德的探究》
英文第一版，精装，由班坦图书公司
（Bantam Books）于1991年出版。

英文1992年版

英文2011年版

西班牙文1992年版

意大利文1995年版

荷兰文2001年版

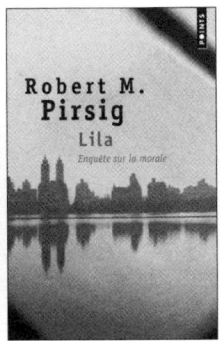

法文2013年版

A CONVERSATION WITH ROBERT M. PIRSIG
与波西格对话

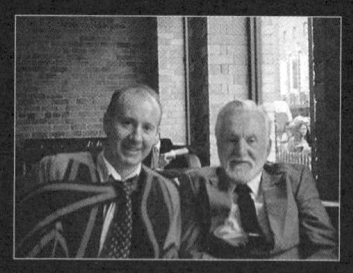

安东尼·麦克沃特博士（左）与波西格（右）

安东尼·麦克沃特是第一位研究罗伯特·M.波西格的学者，他把对波西格"良质形而上学"的研究写成一篇博士论文，题为《罗伯特·波西格"良质形而上学"的批判分析》（*A Critical Analysis of Robert Pirsig's Metaphysics of Quality*），并于2005年获得利物浦大学哲学博士学位。以下为波西格与麦克沃特博士探讨"良质形而上学"的书信，我们摘译其中部分内容，以期为深度阅读《莱拉》提供助力。

——编者

对于我本人在"良质形而上学"上的成果，安东尼·麦克沃特比其他任何人更接近于继承了"正法"。所谓"正法"意为超越一个人个体自我的责任。正是这种"正法"的意识使我历经四年写出了《禅与摩托车维修艺术》，尽管在当时没有人，包括我自己，认为它能出版。我想，也是这同一种意识使安东尼·麦克沃特将这么多年来持之以恒的研究，整理与扩展出这一论著。他为这一工作殚精竭虑，因为他并不想只是用一些哲学细节去迎合你或帮你入门。他做这一工作的目的是，在最高程度上，永久地扩展和提升对哲学内涵的认知。"良质形而上学"是一条理解宇宙的全新路径，但是，正如麦克沃特在其论著中清楚展示的，它的结论未必是错误的。

——罗伯特·M.波西格，2003年

在很多方面，《禅与摩托车维修艺术》一书包含了"良质形而上学"中最重要的部分，是累积而成。《禅与摩托车维修艺术》是归纳之作，《莱拉》是演绎之作……《禅与摩托车维修艺术》的累积起于写作的归纳性经验，终于一个词——"良质"——终于"良质形而上学"的核心。

——罗伯特·M.波西格，1993年

佛教徒有一条戒律，反对没完没了的闲聊。我认为这条戒律背后的道理正是启发我的东西。

——摘自罗伯特·M.波西格给博德瓦·斯库特维克（安东尼·麦克沃特的朋友）的信，1997年8月17日

Robert M. Pirsig
c/o Bantam Books
1540 Broadway
New York, NY 10036
January 15, 1994

Dear Anthony McWatt,

Glad to see you are deep into Ayer and James. The answers to your questions are:

1. I don't have any particular thoughts about active and passive static and Dynamic Quality except that they are useful in freeing one's self from the idea that Dynamic Quality is *always* active and static Quality is *always* passive. There is a natural tendency in everyone to say Dynamic quality *is* this or *is* that, and they may be right at the moment they say it. But the next minute what they said will have become static.

2. The free market does sometimes become static in its workings, particularly where monopolists and price-fixers conspire to restrict it, but then it's not really a free market any more, and some government regulation is needed to protect its freedom. But, as the communist and some of the socialist governments, particularly Sweden, have shown, government regulation can be just as constrictive, and a democratic political remedy is needed. Labor is commonly exploited in the name of "free-enterprise" but in my opinion labor unions, as business agents for the workers, are very much a part of the free enterprise system, and tend to equalize economic forces.

3. I have thought about something like a READER many times. I have never seen a true READER however and am curious as to what you think a READER should look like. If there is a good one you can recommend as an example I will try to buy it here. Also I am very interested in any criticism of the MOQ, friendly or otherwise which can be a starting point for a READER. My problem is that the MOQ is clear to me and so I don't really know what points are most in need of clarification.

4. The Sioux concept of self and higher self is one I hadn't heard of. It first sight it seems like a striking confirmation of the universality of mystic understanding. In Zen Buddhism "Big-Self" and "small-self" are fundamental teaching concepts. The small-self, the static patterns of ego, is attracted by the "perfume" of the "Big-Self" which it senses is around but cannot find or even identify. (There is a Hindu parable in which a small fish says, "Mother, I have searched everywhere, but I cannot find this thing they call *'water.'*") Through suppression of the small-self by meditation or fasting or vision quests or other disciplines the Big-Self can be revealed in a moment sometimes called 180° enlightenment. Then a long discipline is undertaken by which the Big-Self takes over and dissolves the small-self into a 360° enlightenment or full Buddhahood.

Best regards,

波西格给麦克沃特博士的信

为什么波西格专门选择了"静固"和"跃动"两个词来表述他的形而上学理论？

波西格选择"静固"和"跃动"是因为在他的观念里，它们具有最高的"良质"。他做如是观是因为当认出一切思想都是"静固的"之后，它们就能阻止哲学家的一个习惯性冲动，即认为一切能够被言说的都不过是词语，而且永远不可能超出词语的范畴。

跃动的现实是禅宗的教导一直聚焦的所在。哲学家难以理解静固和跃动的实在之间的区别，可能是因为他们想把所有的良质都包含和统摄到思维模式下面。静固良质和跃动良质的区分就是要阻止你这么做。

——摘自博德瓦·斯库特维克给安东尼·麦克沃特的信，1997年9月30日

"模式的"和"无模式的"两种叫法也可以，除了一点，就是"无模式的"隐含着一无所有，一切归于沉寂的意味。没有"东西"意味着什么都没有，就是说，没有"对象"。佛教徒说的"空"就是这个意思。但是"跃动"一词更契合禅师卡塔吉里·罗希 (Kategiri Roshi) 的话："空中有大法 (Within nothingness there is a great working)。"

在我看来,逻辑实证主义者的基本错误在于,他们假定了,因为哲学和语言文字有关,所以只和语言文字有关。这和"吃掉菜单而不是吃菜"是同样的错误。他们的论辩策略都是说,凡是不能通过他们的语言分析的小盒子的东西都不是哲学。但如果关于什么是"好"(它从根本上说是超出语言之外的)的讨论不是哲学,那苏格拉底就不是哲学家了,因为这是他的中心话题。

——摘自罗伯特·M.波西格给安东尼·麦克沃特的信,1997年8月17日

跃动良质跟静固良质是怎样区分开的?

波西格造出"跃动良质"一词来指称即刻实在的不息变动之流,而静固良质指称所有从这流动中抽象出来的概念。波西格将跃动良质等同于菲尔莫·诺斯洛普 (F.S.C. Northrop) 的"未定的审美连续性"。后者指经验中的神性,而且只有通过直接感知才能恰当地予以理解。因此有了"跃动"一词,它指的是不固定、未定的事物。说到底,跃动良质显然不能被这样定义,对它的正确理解只能通过类似开悟之类的神秘体验。赫伯特·冈瑟 (Herbert Guenther) 补充道:"终极,在佛教中,是可知的东西,尽管不是通过理论或推理的方法,而是通过直接的体验得到。"(Herbert Guenther, *Philosophy and Psychology in the Abidharma*, Random House, 1957, p. 235.) 换句话说,佛陀不能告诉你跃动良质是什么,但他能指出一条路让你自己去体验,然后你就懂了。

——摘自安东尼·麦克沃特《关于罗伯特·波西格的"良质形而上学"》

不要让任何"概念"进入跃动良质,这一点非常重要。概念永远是静固的,一旦概念进入跃动良质,就会把它涨破,并试图用某种概念本身来代替它。(举例来说) 我认为最好把时间看成是一个静固的心智概念,它是从跃动良质中最先浮现出来的概念之一。这可以保持跃动良质的概念无关性。

对于相信主客体形而上学的人来说,时间只是一个麻烦。因为如果时间不具有任何对象的属性,那它就必然是主观的。而如果时间是主观的,那就意味着牛顿的加速度定律以及其他许多物理定律都是主观的。在科学世界里,没人想要这个结果。

所有这些都指向"良质形而上学"和经典科学的一个巨大的关于基础形而上学的分歧:"良质形而上学"才是真正经验性的,而科学不是。经典科学始于客观世界——原子和分子——就是终极实在的观念。这种观念当然得到了经验观察的支持,但它并不是经验观察本身。

——摘自罗伯特·M.波西格给安东尼·麦克沃特的信,1997年10月6日

为什么波西格在他的形而上学中使用"跃动良质"而不是别的什么带有神迷色彩的词汇，比如"空"或"一"来表示终极实在？

"一"是通往认识高山的一条心智之路。"空"是另一条这样的道路。(跃动)良质是第三条。当一个只相信科学的脑袋听见"物质"一词时，它就会说："这就是实在。"当它听说"一"和"空"时，它则说："那不过是空洞的、毫无意义的形而上学臆造。它是说给那些相信上帝的人的，对此我们已经通过实证推理否定了。科学地说，这些词汇没有任何意义。""良质"一词优于"一"或者"空"，因为科学家不可能把它当成形而上学的臆造来拒绝它。他们当然想，但他们做不到声称这个世界没有价值存在。就算一个平平无奇的哲学家也能用辩证法把他们碾成碎片。"良质形而上学"的价值就在于它给出了一个核心词语，它是西方的那些科学化、条框化的头脑无法驱除的。

——摘自罗伯特·M.波西格给安东尼·麦克沃特的信，1995年11月24日

如果跃动良质仅仅被叫作"上帝"或"一"，(科学家)会毫无疑问地把它踢出场地。但他们不能把"良质"踢出去。不管它是不是神秘主义，他们都不能否认它的存在。他们不能把它作为一个有意义的术语清除掉。事实上，"有意义的"就意味着具有社会或心智良质。

——摘自罗伯特·M.波西格给安东尼·麦克沃特的信，1997年8月17日

良质的四种静固模式是怎样相互关联的?

"良质形而上学"认识到,良质的四种静固模式通过一种全宇宙层面上的"演化"关联在一起。如果把大爆炸作为宇宙的起点,就会发现这个时间点上只有无机良质的模式,也就是化学和量子力。从那往后,在一个个连续的历史阶段,植物和动物从无机模式演化出来,社会从生物模式演化出来,心智从社会演化出来。

——摘自安东尼·麦克沃特《关于罗伯特·波西格的"良质形而上学"》

宇宙从低良质的状态(只有量子力,在大爆炸前没有原子)向更高的层次(鸟类、树木、社会和思想)演化,从静态的意义上看(日常事务的世界)这二者是不一样的。

——摘自罗伯特·M.波西格给安东尼·麦克沃特的信,

1997年3月23日

为什么在"良质形而上学"中"演化"成为一个重要的考量因素?

和佛教一样,"良质形而上学"认为,在业力之轮上,最好的位置是枢轴而非轮辋,在轮辋上的人被日常生活抛来掷去。但是在"良质形而上学"眼中,业力之轮是连在一辆车上的,这辆车正通往某处——从量子力,经由无机模式和生物模式以及社会模式,直到感知到量子力的心智模式。在公元前六世纪的印度,没有任何如此这般演化过程的证据,佛教,自然地,也没有注意到它。今天,我们已经不可能还这样无知了。佛教徒眼中必须逃离的痛苦,在"良质形而上学"看来,不过是向着良质进步的消极面(或者,准确起见,叫作良质的外扩)。没有痛苦的驱动,这辆车根本不会前进。

——摘自罗伯特·M.波西格给安东尼·麦克沃特的信,

1997年3月23日

那么，这样一个道德框架的意义何在？

在将道德从社会习俗中切割出来，并置于一个基于科学的演化理论上之后，"良质形而上学"在很大程度上消除了因袭在伦常观念中的文化主观性。

此外，"良质形而上学"通过一个来自宇宙原初的全方位视角，对很多原来非常困难的问题给出了新的解答。这些问题包括心物关系问题、因果关系的本体论问题、自由意志和决定论的问题。当应用演化的方法时，双方的问题都是可以解决的。

——摘自安东尼·麦克沃特《关于罗伯特·波西格的"良质形而上学"》

在"良质形而上学"中，由于概率和选择都是价值的子集，在描述从量子到人类层级的行为时，这些术语都是可以互换的。关于概率和选择，波西格有如下论述：

当检视二者的差异时，有趣的事情发生了。选择总被认为是主观的。它只存在于心智和社会层级中，在生物层级它就充满争议。比如，猫能作出选择吗，还是说它的行为只是依据斯金纳的条件反射概率？而在原子水平，一般认为只有概率存在。

"良质形而上学"结束了古老的自由意志和决定论之争，它指出选择和概率都只是价值的子集。由于主体和客体的区别在"良质形而

上学"中变得相对不重要，概率和选择的区别也是如此。在自由意志面前，心物之间并没有根本差异，只是自由的程度不同罢了。亚原子力也可以表达有限的选择。

——摘自罗伯特·M.波西格给安东尼·麦克沃特的信，1997年5月3日

我见过关于这一主题的流行图书：《物理学之道》(The Tao of Physics)、《舞蹈的物理大师》(The Dancing Wu Li Masters)，它们看起来非常急切地想要从相似性的观察跳跃到同一性的陈述，但是请当心，要遵从科学的戒律，不要说那些超出你认知范围的事情。通过和物理学家对话并揣度他们对佛法世界的理解程度，我个人的观点是，他们什么都不懂。整个科学是反对神秘主义的。(物理学家)或许已经开始反对客观性，但那并不是他们的基础。没有一堂高中物理课会这样说："整个世界是一个幻觉。"在一个科学的社会里谈论神秘主义，就好像在大马士革谈论犹太教。他们也许会听你说，但是这与他们受到的教育完全背道而驰。

——摘自罗伯特·M.波西格给安东尼·麦克沃特的信，1997年3月29日

ABOUT THE BOOK
关于本书

INTRODUCTION FROM ROBERT M. PIRSIG
波西格关于《莱拉》的介绍

《莱拉》的前作《禅与摩托车维修艺术》是关于一个人为追寻"好"的真义而一路追到"涅槃"哲学的故事,他把这真义叫作"良质"。不幸的是,故事发生所在地的文化认为他的所作所为是精神不正常的表现。

续作《莱拉》则试着呈现,当他的"良质"被作为终极实在之后,将如何拓宽和提升我们对几乎一切事物的基本认识。为了确保这一阐释,即"良质形而上学",在逻辑上无懈可击,我用了十七年。

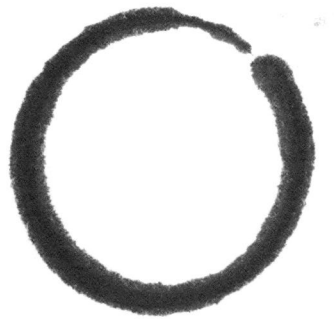

禅宗有时被形象化为一个圆。这个圆的底部是一个修禅者开始的地方,经过一百八十度到达圆的顶部时就是禅宗的开悟。在这里,

修禅者已经彻底地摆脱了世间的日常俗事，有时被叫作"小我"，同时迈入了佛的世界，或者叫"大我"。

但这个圆只完成了一半。这个此前被日常生活的种种事务推动着的修禅者，现在在佛的世界里被称为"法"(dharma)的力量推动着。"法"被翻译为"责任"(duty)，但它的含义比责任要深得多。他不仅仅是循着法，他还与法合一。他完成了这个圆。以开悟的心智回到来处，他使自己与世间的日常俗事圆融一体。

《禅与摩托车维修艺术》是这个圆的上半程，《莱拉》则是进入后一半的旅程。《莱拉》的第一章中反复使用了"降"字来加强这一形象。

许多先读过《禅与摩托车维修艺术》的读者会因为《莱拉》的沉闷和技术性感到失望，然而意外的是，许多先读过《莱拉》的人却认为《莱拉》更好。不论哪一种情况，他们都是在希求更多他们已经读到的东西，结果希望落了空。但是，如果你能够理解，这两本书行走在相反的方向上，共同完满了一个圆，那对它们的目标就了然了。

在《莱拉》中，斐德洛被日常生活的琐碎淹没了，但是他并没有被这些控制，也没有试图像在《禅与摩托车维修艺术》中会做的那样从中超脱出来。如今，他的"法"在指引着他找到理解世界的更好的方式。这多少从中排解了几分压抑，也显现出它为什么存在。他的时间被同时用在了处理莱拉的问题和思考他的"良质形而上学"上。

书籍用一种奇怪的方式在书写自己。它们会告诉作者什么是它们想要的，而他最好听一听，否则就会写出一本艺术上拙劣的作品。《禅与摩托车维修艺术》的第一稿是按照作者的方式写的，而不是书的方式，结果两年以后不得不被抛弃。

　　莱拉这个人物一开始完全错了。她被作为一个年轻纯真的小甜心，唯一的目的就是向斐德洛抛出哲学或者航行的问题，然后他就用他的大智慧一一作答。

　　太恶心了。这本书忍受不了。到了第七章开头笔就停下了，而且怎么也写不下去，除非莱拉这个人物得到调整。

　　经过五次重写，莱拉的形象从一个甜美的年轻小姐一次次向着泼辣的老娼靠近。她利用斐德洛，而且一点都不喜欢他。在第六次重写中，她精神失常了。这是一个突破。这本书终于亮了绿灯，而我关于她已经写下的一切都要进行修改。现在斐德洛真的下降到了日常生活的琐碎当中，画完了禅的圆。

　　所以《莱拉》的终稿可能是让每个人都不舒服的一本书，因为没有人理解其他人，甚至连想都不想。它的故事想要反映出"良质形而上学"中阐释的静固模式。斐德洛、瑞乔和莱拉彼此磕磕碰碰，因为每个人都活在不同的价值模式中。斐德洛基本是心智的，瑞乔基本是社会的，莱拉基本是生物的。他们谁也受不了谁，但是放在一起，却构成了一副颇堪玩味的生活画面。

——罗伯特·M.波西格　2011年

INTERPRETATION FROM XU YINGJIN

徐英瑾关于《莱拉》的导读：
溯流而上的"良质"探究传奇

复旦大学哲学学院教授、博士生导师，从事人工智能哲学、英美分析哲学的研究。论文《维特根斯坦哲学转型期中的现象学之谜》获全国优秀博士论文奖，著作《心智、语言和机器》获全国"科史哲"青年著作奖，被评为2009年度"上海十大社科新人"。

本书的作者美国作家罗伯特·波西格（Robert M. Pirsig, 1928—2017）是一个奇人。他在少年时代就流露出特殊的才情，早早就在明尼苏达大学读起了化学，却因为爱钻牛角尖退了学。随后他在美军驻韩基地当过兵，做过修辞学教师，也经历过痛苦的精神崩溃，做过电脑程序员，还带着自己的儿子骑着摩托车横穿过美国。最后他将人生道路上的各种体会都凝练为一部哲理小说《禅与摩托车维修艺术》，并通过这部小说成为西方世界大有名气的畅销书作家。大家看到的这本《莱拉》便是《禅与摩托车维修艺术》的姊妹篇。仿照前书夹叙夹议的写作方式，本书其实也讲了这么一则故事：

本书的主人公名叫"斐德洛"（这其实就是作者本人的某种侧写，而且该名字在《禅与摩托车维修艺术》中也多次出现过）。斐德洛驾驶着一条船沿着哈德逊河往纽约方向开，并在途中载上了一名叫"莱拉"的女乘客。莱拉是主人公在酒吧里遇到的一位有点疯癫的女士，二人邂逅时她正遭遇一场精神崩溃。面对莱拉，本人也曾经历过精神崩溃的斐德洛不禁开始思索起"疯狂"与"正常"之间的界限究竟是什么。他们的船在纽约曼哈顿靠岸之后，两个人暂时分开，各自去忙自己的事情了。但在二人分别之际，莱拉的精神状态不知何故又开始恶化，而当斐德洛重新发现她时，她手里正紧紧抓着一个玩具娃娃。这时斐德洛下定决心，要照顾她的余生。二人后来又坐船离开了曼哈顿，去了另外一个叫"桑迪胡克"的港口。没想到事情却在这时候发生了反转。二人在那里遇到了一个叫"瑞乔"的船长——其实他在故事里早就出现过了，只是一度离开了主人公而已。莱拉告诉斐德洛，她决定离开他跟瑞乔走，而且

她早就这么盘算了。这让主人公非常惊讶。更让他震惊的是，瑞乔也告诉他，莱拉在曼哈顿的时候就一直追逐自己，而且还对自己说，斐德洛想杀了他。莱拉的不诚实行为固然让主人公一度很受伤——但在她离开自己后，他还是重拾心情，继续对他所心心念念的"良质形而上学"进行探究。

与上述故事情节相平行，这部小说中夹杂了作者本人大量的哲学议论，而前面提到的瑞乔就往往是以哲学论辩中的"反方"出现的(譬如，当主人公认定貌似疯癫的莱拉身上有"良质"的时候，瑞乔就竭力反对这个看法)。作者还见缝插针地以斐德洛的口吻，向读者介绍了他目下正在进行的研究规划。与《禅与摩托车维修艺术》对于摩托车的关注不同，这次他关注的对象乃是人——于是他首先开始了人类学的研究。在这个过程中他回忆起了他的老朋友沃尼·杜森伯里——他是一位在学术圈混得不怎么好的普通英文教师，却对印第安文明有着深入的见解。斐德洛从他那里得到洞见，意识到美国文明实为欧洲文明与印第安文明的融合体，而不能被简单地归类为任何一种既有的文明。但是，主流的人类学研究方法却硬是要将机械的分类法则贯彻到对于人类文明的多样性的研究中去，这使得作者最终领悟到人类学的现有状态是无法满足他的理智好奇心的。于是他将研究的重点又转向了"良质形而上学"。

"良质"这个概念其实在《禅与摩托车维修艺术》中早就出现过多次。在那本书中，"良质"主要是指某种融合西方浪漫主义传统与理性主义传统的更高级的精神存在——比如一个优秀的摩托车手在维护摩托车的时候所达到的那种"物我两忘"的状态。而在本书中，

七十七岁的波西格 Ian Glendinning 供图

作者对于"良质"的探究则更多具有了价值哲学的维度——或者说得更通俗一点,此类探究将更多地涉及"什么是好的或是道德的"这一问题。对于这个问题,斐德洛拒绝给予一种简单的回答。他更愿意以一种类似于黑格尔在《精神现象学》中所展现的"认知螺旋上升"的方式,将对该问题的回答由低到高切分为不同层次:

在最低的层次上,我们看到的价值乃是属于无机界的——只要无机界涌现出秩序,相对于那种更原始的混沌状态来说,这便是"更好"的;第二个层次上的价值乃是属于生物界的——只要生物的持存能够以克服无机界的单调性的方式而得到保证,这便是"更好"的;

第三个层次上的价值则是属于社会的——只要社会规范的强制性能够超越人的生物性，这便是"更好"的；第四个层次上的价值则是属于"心智"的——只要个体心智的自由驰骋能够突破社会规范的束缚，这便是"更好"的。

以上这四种价值，都被斐德洛视为"静固良质"，以便与所谓"跃动良质"相互对应。不过，给"跃动良质"以正面定义乃是困难的，我们姑且将其理解为一种对于既有的静固价值规范的破坏力量。也就是说，无机界对于混沌的克服需要"跃动良质"，而心智良质对于社会规范的克服也需要"跃动良质"（余者读者可自行类推）。没有这种跃动良质，整个世界将始终是一潭死水，无法实现真正的进步。

一些读者会问：作者对于这些貌似抽象的问题的讨论，到底有何现实意义呢？

对于这个问题的回答，必须结合美国二十世纪六七十年代的社会背景来进行。当时美国社会发生了三件事情：第一，反越战运动蓬勃兴起；第二，嬉皮士运动方兴未艾；第三，黑人民权运动如火如荼。这三种运动又彼此合流，对美国传统的三大价值支柱构成了冲击：第一是爱国主义；第二是英式维多利亚文化的美国版本（请注意，即使到了今天，维多利亚文化依然死而不僵，否则就没那么多人爱看《唐顿庄园》了）；第三则是臭名昭著的白人至上主义。如何对当时兴起的这些复杂的精神运动进行合适的价值评价，便成为摆在美国知识分子面前的紧迫任务。但不得不承认的是，要精确地给出相关的评价，本身便是极为艰难之事，因为当时美国年轻人的精神世界可谓良莠不齐。一方面，反战与反种族歧视

的观点的确具有明显的进步性；但另一方面，对于传统价值观的全面诋毁则又会导致家庭的解体与人类生物学本能的复归。至于那些敌视新文化思潮的保守主义分子，则又一股脑地将其视为洪水猛兽，而不愿意仔细区分其中哪些是需要被倒掉的洗澡水，哪些是不能被倒掉的澡盆里的孩子。面对这样的复杂局面，波西格便觉得自己有责任提出一种更为复杂的价值学说来厘清世人的思想，以便精准地厘定六七十年代美国文化思潮中的光明面与阴暗面。

在波西格看来，以嬉皮士运动为代表的美国六七十年代中的光明面，便是此类运动充分体现的"跃动良质"摧毁旧价值体系的破坏意义。所谓"不破不立"，国家机器对一个遥远的东南亚小国的军事凌霸、维多利亚价值观的矫揉造作，以及黑人长期以来所遭受到的不公正待遇，的确都需要某种与之对抗的力量使之得到纠正。但问题是，为反对而反对并不能真正解决问题。具体而言，嬉皮士运动最终放出了性解放与致幻剂泛滥这两个洪水猛兽，这实际上就是用比"社会良质"更低等的"生物良质"去克服在"社会良质"层面上的问题——其荒谬程度，就好比人们为了克服使用汽车出现的问题而去重新使用马车。这一层次混淆的问题甚至在黑人民权问题中也得到了体现：实际上，任何人都是生物学存在与社会性存在的结合（黑人自然也不例外）——因此，所谓"美国黑人问题"其实是有着明确的社会学维度的（比如，站在马克思主义的角度看，所谓种族问题是有明确的阶级烙印的）。而波西格看到的美国的现实却是：只要争端双方牵涉黑人、白人两个种族，那么对该争端的定性就肯定是"种族问题"，否则就是"政治不正确"。这无

疑又是生物学规范僭越社会规范的一个鲜活案例。

为了与这些简单粗暴的价值分类原则相对抗，波西格苦心孤诣地构造出了一套复杂的价值观体系，以便让读者明白评判好坏善恶的价值尺度是具有多元性的，切不可用"平权主义抑或保守主义""民主党抑或共和党"这样简单的极化思维来臧否一切。联想到今日美国文化高度分裂的现实，波西格的评论可谓一语中的——不过，这从另外一个角度也意味着波西格的哲学普及工作的失败：因为与波西格还健在的时代相比，在今日的美国，他所痛恨的价值标准的混乱问题反而愈演愈烈了。

尽管如此，我们依然可以在此书的行文中读到作者对美国文化的热爱与希望，真可谓"爱之深，恨之切"。作者对莱拉这个女性的复杂态度其实也正是他对美国文化的复杂态度的浓缩——尽管他知道莱拉也面临着与美国一样的精神分裂，而且他最后也知道自己被莱拉欺骗了（正如美国也不时地欺骗她的人民一样），但是他依然坚信莱拉是具有良质的。同时，被莱拉欺骗后斐德洛重拾心情的过程本身也代表着作者本人的良质觉醒过程中一个更高的辩证法环节。

毋庸讳言，今日的中国思想界也在经历着不同意见之间的巨大撕裂，却罕有人进行彻底的反思。希望本书能够启迪国人心智，最终使得中国文化中的"良质"，能够以一种平衡"静固力"与"跃动力"的方式而得到更恰当的呈现。

徐英瑾 2022年8月

READ ON
拓展阅读

35

BOOKS AND BEYOND

《莱拉》背后的作家与作品

波西格在写作《莱拉》时,以下作家与作品从不同维度曾给予波西格以启悟,涉及人类学、生物学、文学等诸多领域。

马 克 · 吐 温 :《汤 姆 · 索 亚 历 险 记》
The Adventures of Tom Sawyer by Mark Twain

罗 伯 特 · 迈 纳 斯 、大 卫 · 卡 普 兰 :《人 类 学 理 论》
Theory In Anthropology by Robert A. Manners and David Kaplan

A. L. 克鲁伯、克莱德·克拉克洪：《文化：对概念和定义的批判性回顾》

Culture: a Critical Review of Concepts and Definition by A. L. Kroeber and Clyde Kluckhohn

鲁思 · 本尼迪克特：《文化模式》

Patterns of Culture by Ruth Benedict

沃克·珀西:《Delta因子》

The Delta Factor by Walker Percy

大卫·G.曼德尔鲍姆:《平原上的克里人》

The Plains Cree by David G. Mandelbaum

《梨俱吠陀》
The Rigveda

荷马：《奥德赛》
The Odysseia by Homer

沃尔特·李普曼：《道德序言》
A Preface to Morals by Walter Lippmann

索尔斯坦·凡勃伦：《闲暇阶级之理论》
The Theory of the Leisure Class by Thorstein Veblen

玛格丽特·米德：《萨摩亚人的成年》
Coming of Age in Samoa by Margaret Mead

杰克·凯鲁亚克：《在路上》
On the Road by Jack Kerouac

莲花生大士：《西藏度亡经》
The Tibetan Book of the Dead by Padmasambhava

马 塞 尔 · 普 鲁 斯 特：《追 忆 似 水 年 华》

A La Recherche Du Temps Perdu by Marcel Praust

埃 尔 · 格 列 柯：《耶 稣 诞 生》

The Nativity by El Greco

罗 伯 特 · 赫 兹：《右 手 的 优 势》

La Prééminence de la Main Droite by Robert Hertz

约 瑟 夫 · 坎 贝 尔：《上 帝 的 面 具》

The Masks of God by Joseph Campbell

威廉·詹姆斯（William James）

E. A. 胡贝尔（E. A. Hoebel）

弗朗兹·博厄斯（Franz Boas）

爱德华·萨丕尔（Edward Sapir）

朱迪斯·布莱克（Judith Blake）

金斯利·戴维斯（Kingsley Davis）

赫伯特·费格尔（Herbert Feigl）

亨利·庞加莱（Henri Poincare）

让-巴蒂斯特·拉马克（Jean-Baptiste Lamarck）

阿尔弗雷德·拉塞尔·华莱士（Alfred Russel Wallace）

恩斯特·瓦尔特·迈尔（Ernst Walter Mayr）

列维-施特劳斯（Levi-Strauss）

伊迪丝·沃顿（Edith Wharton）

欧内斯特·米勒尔·海明威（Ernest Miller Hemingway）

舍伍德·安德森（Sherwood Anderson）

约翰·多斯·帕索斯（John Dos Passos）

D. T. 坎贝尔（D. T. Campbell）

M. K. 奥普勒（M. K. Opler）

克利福德·格尔茨（Clifford Geertz）

艾萨克·弗罗斯特（Isaac Frost）

阿道司·伦纳德·赫胥黎（Aldous Leonard Huxley）

约翰尼斯·埃克哈特（Johannes Eckhart）

PRAISE FOR *LILA*
《莱拉》全球媒体评论

★包罗万有、论点迭出的特点……使你在书页间跌来荡去。叙述者的话中带有一丝马克·吐温式的街头气息和市井智慧。

——《星期日时报》

★波西格的文字中满是令人心智大开的洞见和催人深省的见地。

——《卫报》

★这是一本我会反复阅读的书……又一本使我感谢有它存在的书。

——《苏格兰人》

★终于，波西格用他的新小说《莱拉》完成了他的续作。如果安逸的九十年代对它视而不见，那不是波西格的错；他已经写出了另一本挑战心智的著作。

——《多伦多环球邮报》

★是什么驱动着人类前行？探讨这一问题的哲学求索永远令人心醉神迷。

——《出版消息》

★诸如精神/物质和自由意志/决定论这样的大问题，像变戏法一般被砰然消解了……世界被塑造成生物、社会和心智价值模式。在它们之上的，更高级的是跃动良质，神秘的开端和终点。

——《市界》

★在它身后，对发疯和现实的可怕认识仍然存在，这使你意识到，它被写出来是因为它非写出来不可……这趟旅程非常值得。

——《超时》

★《莱拉》让思想大快朵颐。

——《洛杉矶时报》

★读者也跟着耳畔生风,并在这场穿越现代哲学景观的激动人心的无尽航程中得到启悟。

——《纽约时报》

★极具原创性,发人深省……一场搭配奇异的精彩四重奏即兴曲:航行、哲学、性和疯狂……《禅与摩托车维修艺术》一书毫不逊色的续作,前者或许是当代最具影响力的大众哲学著作。

——《纽约时报》

★引人入胜的作品。在为数不多的研究美国文化面貌的声音里,波西格可谓独一无二。

——《堪萨斯城市之星》

★《莱拉》,正如它的前作,是一部思想异端之书,一部孤独之书——是一个思想深刻、性情敏感的社会与文化观察者的记录。他早已厌倦学院派的装腔作势和虚伪,更不用说那些形形色色的俗世专家们的傲慢了。

——《华盛顿邮报·图书世界》

★波西格的写作是真正的探险之旅,充满惊险、挑战和意外发现。

——《星际论坛报》

★作者追问的继续,当之无愧。

——《基督教科学箴言报》

★说到底,是他的旁白、深思、异见和对"好"的热忱求索,使他的书引人如斯——更不消说他极端的个人色彩,还有在面对他眼中的歌利亚时,他那令人瞠目的、几乎是自毁式的想要扮演大卫的冲动。

——《洛杉矶时报》

★《莱拉》具有宽广的视野,澎拜的理性和顽强的个性,它使波西格跻身于这些大师和跨文体的同僚之列,如托尔斯泰、梅尔维尔和狄更斯……《莱拉》充满力量……缘于个人创见的强光,那一秒一秒的时间感,以及我们称之为天才的那种风范……它属于这样的书……对我们的文化来说,它是一份不期而遇的礼物,能帮助我们改变,帮助我们生活。

——《芝加哥论坛报》

★张力不亚于《禅与摩托车维修艺术》,或许还更胜一筹。

——《波士顿环球报》

★扣人心弦……引人入胜,不折不扣的波西格——他的书迷们不会失望。

——《科克斯评论》

★《莱拉》……能让你清晰、深入而且欣喜地理解当代哲学的问题……能做到这一点的书寥寥无几。

——《纽约时报》

★波西格广阔的哲学探索将向读者发起挑战并牢牢抓住他们。

——《出版商周刊》